© 2002 Mandragora. All rights reserved.

Mandragora s.r.l.
Piazza Duomo 9, 50122 Firenze
www.mandragora.it

Edited, designed and typeset by
Monica Fintoni, Andrea Paoletti, Franco Casini

Printed in Italy
ISBN 88–85957–87–0

This book is printed on TCF (totally chlorine free) paper.

Douglas Lew

A Watercolor Journal of Florence

*To Anne,
Best wishes
and good painting
Doug Lew*

Mandragora

FOREWORD

Douglas Lew brings a spirit of artistic creativity and a subtle sense of humor to everything he does. His professional career as creative director for Ruhr/Paragon—a Minneapolis, Minnesota, advertising agency—was always informed by his concurrent activity as a painter. While his billboards and television commercials have brought delight to the millions who saw his work but never knew the creator, his watercolors are recognized by collectors who are well aware of his reputation as a fine artist.

I first met Doug in the late 1970s when we worked together on an exhibition from the Hermitage Museum in St Petersburg, Russia. It was a time when 'blockbuster' international exhibitions were just beginning to capture the imagination of the American public and the exhibit was intended to tour to many cities in the United States. Doug was just beginning to shape a presentation that would bring the treasures of this great museum to the attention of the people of the United States when politics intervened and the exhibit was canceled. The first-hand knowledge of these great works of art from the Hermitage remained with Doug and I believe still influence his work today.

Doug began to study watercolors as a young student in China. After he came to the United States as a fifteen-year-old, he continued his study of art and completed degrees in art and history. His career as commercial artist took him to New York, Los Angeles, and finally to Minneapolis, where he still makes his home. Parallel to his career in advertising, he developed new watercolor techniques, won prizes, and wrote books about watercolor painting.

Doug began this series of small sketches of the city of Florence in 1992, when he rented the house of a friend and spent time getting to know the city as only an artist can. He filled his eyes with the paintings, sculptures and architecture of the historic city, and his other senses absorbed the sights, sounds and smells of a contemporary city.

Florence has fascinated travelers for centuries—among them writers, artists and musicians. Rinuccio in Puccini's opera *Gianni Schicchi* sang, "Florence is like a tree in flower". English novelist Charles Dickens wrote in 1844 that in Florence artists were remembered, while kings and warriors "show so poor and small and are so soon forgotten". German composer Felix Mendelssohn, who first visited Italy in 1830, wrote of Florence: "There are flowers and grapes and olive leaves, the

sharp points of cypresses and the flat tops of pines, all sharply defined against the sky". Turn-of-the-century grand tourers from novels of American Henry James and English E.M. Forster roamed the gardens of Florence and sketched in the Uffizi Gallery. For young American and particularly English visitors at the turn of the 20th century, Florence epitomized the exotic. It offered a place for escape from the strict social conventions of Victorian England and America in a setting that was seductive with its combination of graceful architecture surrounded by hills and pines, a languid river crossed by ancient bridges, a warm soft climate, and people who always seemed (and still seem) to have time for a leisurely lunch—with wine!

The city has retained its charm in spite of the hordes of tourists whose visits are made possible by cheap airfares and encouraged by films and literature. A survey of a popular Internet site shows that 846 books are available for sale about the city of Florence. As a city it can seem somber when compared to the carnival that is Venice or the baroque ecstasy of Rome, but it has a purity and a charm that keeps it first in the hearts of many travelers. My first visit there was in 1969, when I declared it the most beautiful city on earth and vowed to return. Fortunately, I have kept that vow, many times. Doug Lew's watercolors bring, to a frequent visitor like me, a fresh glimpse that sees beyond the familiar views of Giotto's Tower and Brunelleschi's magnificent Dome which dominates the Florentine skyline.

Doug captures not just the sights but the textures of Florence. He understands that Florence is not only its famous historical monuments, but also its markets and restaurants, its doorways and window grills, and its neighborhood displays of intimate apparel lines of laundry. Florence through Doug's eyes includes even its tourists, who flood its streets in search of art, history, and *gelato*.

Doug's watercolors exhibit a trained eye, a spirit of creativity and technical excellence. The returning visitors to Florence will delight in his details that prompt a re-examination of the familiar. And the first-time visitors will cherish this book because it captures, in a very individual way, the Florence that casts a spell over nearly every visitor. It is a virtual mosaic of this city that has been beloved to so many through the ages.

Minneapolis, Minnesota
March 5, 2001

Lyndel King
Director and Chief Curator, Weisman Art Museum

A Watercolor Journal
of Florence

INTRODUCTION

Watercolor condenses time and consolidates experiences.
Frank Marcello

In September 1992 my wife and I had the good fortune to rent a house in Florence for a month from a friend. The house, situated in the heart of Florence on Via Farini across from the synagogue, was a five-minute walk from the Duomo. It was beautifully furnished with every modern convenience. There was a loft, a basement and a spacious patio connecting to a small garden. I had been to Europe many times but had never rented a house. I was too busy touring and traveling and simply did not take the time to paint. Now, for the first time, Linda and I settled down in the house and decided not to travel beyond the confines of the city. We wanted a taste of what it was like to actually 'live' in another city; to walk the streets, to shop in the markets, to buy bread and wine, to cook our own food and to entertain friends—all the things you normally can't do when you're traveling on a tight schedule.

I carefully packed a watercolor set, limiting the color tubes and brushes to a minimum. I found a small lightweight plastic folded palette 8 x 4, and a small 4 x 4 x 2 plastic cup with two smaller cups that fit neatly inside. The paper I chose was Arches 140 lb. cold press which I cut up to fit in a three ring binder 7.5 x 10. I carried all of this in a light canvas bag that weighed only 7 pounds.

The choice of the small-size paper was deliberate: I wanted to do only small sketches that I could complete on the spot—one or two a day. Anything larger would not only be too cumbersome but would take too much time. I had two purposes in mind: one, to record many sights as quickly as possible—a sort of a visual journal; and to accumulate a body of sketches as examples for my students at the University of Minnesota where I teach the use of watercolor in architecture. I tell my students that watercolor is one of the quickest mediums in which to capture the look and feel of an architectural idea. Now I have these sketches—to show them what I mean.

It had been a while since I had painted on location. It isn't an easy task to carry all the necessary equipment while looking for a site. Then once I find it, the exact vantage point may not be a convenient spot from which to paint. Direct sun needs to be shielded. Unpredictable gusts of wind are always a problem. Sitting on a curb can attract attention. Dogs can urinate right next to you and rain can stop everything. In addition, the city of Florence presents its own set of difficulties, with its many historical buildings set on very narrow streets. If I step backwards to look at a building, I may be run over a car, motorbike, baby carriage, or pedestrian. Sidewalks are

often as narrow as my shoulder, and the ever-present motor scooters can literally brush me off my feet as they whiz by with an ear-deafening whine. If all the scooters can be made silent, it would be a God-given blessing. Also, Florence in September can be hot. Venice has the sea, Rome has its fountains, Bologna has arcades, Siena is high. But the heat of Florence offers no relief, not even in Fiesole nor in the Boboli gardens. The insides of churches are the only cool places, but sitting down with brushes in hand doesn't always seem appropriate.

As time went on, I found that copying the sight was increasingly less satisfying to me. The desire to compose for a better 'picture' was always there, urging me on. Copying seemed somehow incomplete. Perhaps I was unconsciously reminded of someone who said that an artist will be remembered for his vision and not his recording.

Before the invention of the camera, accurate visual recording was important, and reached near perfection in the hands of Canaletto and others. In those days, artists were often employed by rich travelers who wanted to show off to their friends the places they visited. I had no desire to duplicate what the camera could do.

It's the same feeling I have when looking at paintings of photo realism. I see a great deal of skill but I find myself asking, what for? The camera can record details that a painter could never hope to duplicate. Painting, on the other hand provides something a camera cannot—a personal vision of the artist.

These sketches are not, by any means, a complete recording of Florence. It was only one artist's exploring eye. I painted and drew what caught my fancy, on that particular day or that particular moment, much like a plein-air painter. In fact, as time went on, I found myself attracted less to historical sights and more to ordinary things that offered, to me, more interesting paintings. I did make notes of what I painted. While I changed and simplified some of the details of the sights, I did try to capture the look, smell, and feel of the place.

I sincerely hope that the joy I experienced in doing these sketches can be transferred to watercolor lovers, to those travelers who love Florence, and to those students of all ages who cherish what Florence offers today and all the days to come.

D.L.

1. The Door

The Duomo is unquestionably the centerpiece of Florence. Its architectural accomplishment is well known but I was surprised by the lack of grounds surrounding it, making it difficult to view it in its entirety. In walking the narrow streets around it I would very often get a glimpse of it, but of only a part of it. I would stumble into the site and there it was.

As always, tourists and horse carriages were forever present obstructing the view. I decided to paint only what was possible for me to see. I settled on the central cathedral door, the height of which is that of a two-story building. The entwining pillars arched to include a mosaic. I went to a nearby cafe, got some water, squatted down some twenty paces from the door, and started to work as fast as I could. The door recedes deeply, so I committed a large swath of shadow to define the recession; it also helped to carve up the space very nicely. The crowd and the noise around me were beginning to wear on my concentration, making me work faster, telling me to go for the overall impression. I quickly put down a suggestion of the details in the pillars and the mosaic, using opaque white sparingly wherever necessary. As a finishing touch, I dashed in some indication of people, gathering on the steps as they always do, in order to give scale to the door.

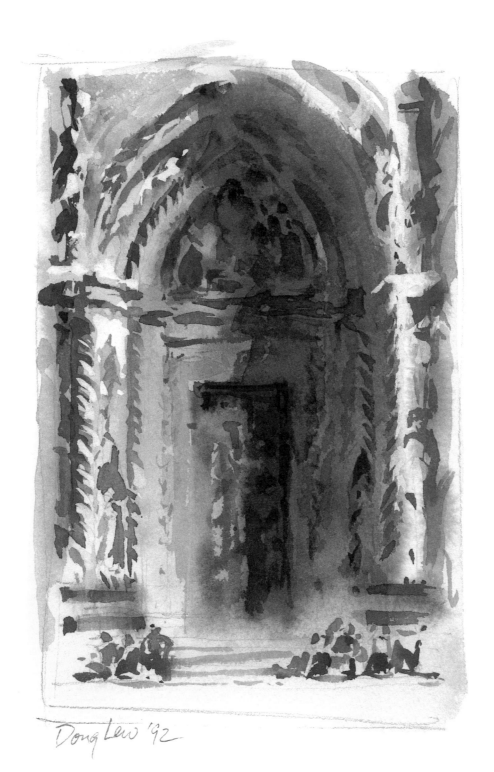

Doug Lew '92

2. Tourists

In depicting the Duomo I had to back away from it as far as possible, but on this day, no matter where I went, the view was always blocked by throngs of tourists. They usually gathered in groups headed by a tour guide who would carry a cane or an umbrella with a little flag at the tip in order to distinguish one group from another. I found myself more absorbed in looking at the people, trying to guess which nationality was which. A thought occurred to me, in a flash, to sketch just the tourists with the Duomo in the background. But how? Then it dawned upon me to make it an ant's-eye view with tourists in the foreground and the Duomo in the background—out of focus.

Two things remind me of that day as I sat on the curb next to an outdoor cafe: a curious waiter who kept coming back to watch me as I sketched and a dog that emptied his water right next to me after sniffing the dirty water in my container. I kept on painting.

3. Horse Carriage

The same day I sketched the tourists, I did this one. As I was painting, this carriage was sitting there, right next to me. I didn't have to move except to empty the dirty water and ask for some more from the cafe. A little boy came to the carriage driver bringing him a big plastic container filled with pasta. He wolfed down the lunch in no time. They spoke for a while as I silently sketched them. A family of tourists came and bargained with him. Before I knew it, they were gone, which explains the sketchiness of the rendering.

4. Dome and Belltower

As I was never able to get a view of the whole, this is the most I could see from a distance. The base of the structure was blocked by other buildings. The circular windows and the surrounding smaller half-domes blend nicely with the central dome. Although using the same color marbles, the belltower does not seem related to the Duomo, and looks thin and fragile next to the massive Dome, although I know its builders doubled the thickness of its walls. Still, the two structures stare at each other like strangers standing side by side.

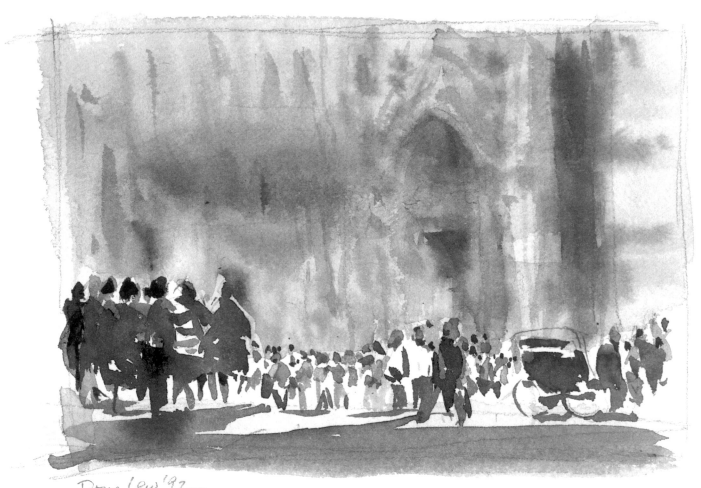

Doug Lew '92

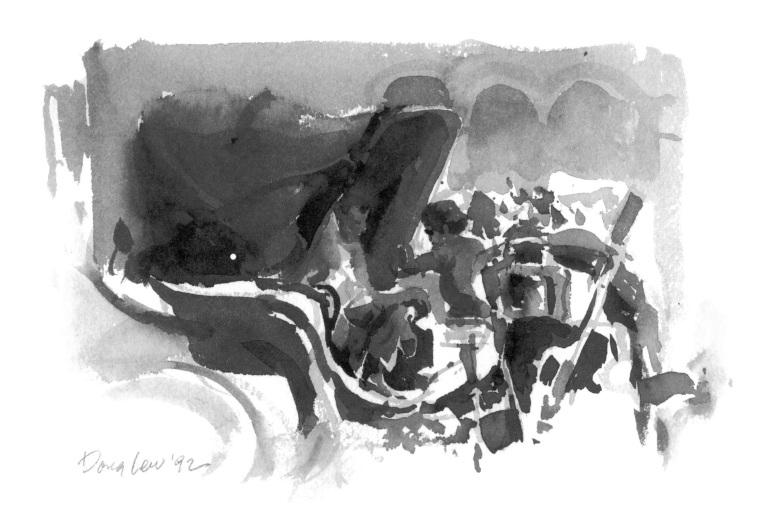

Dona Lew '92

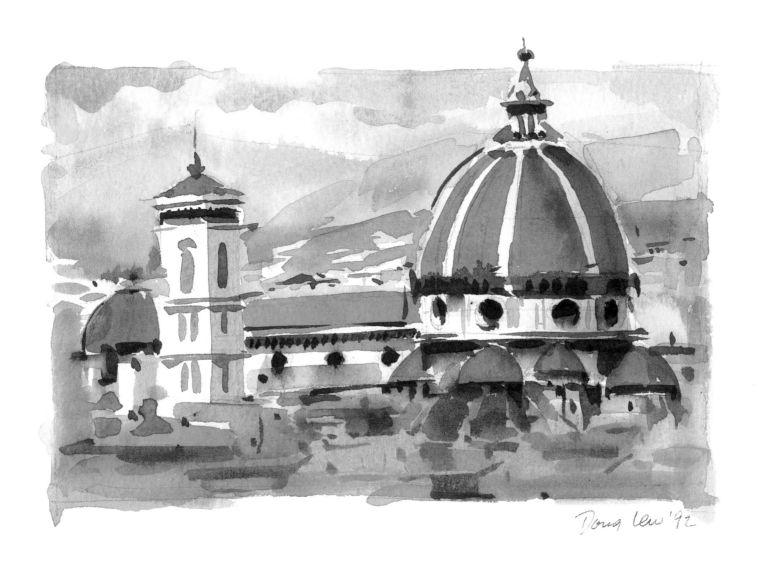

5. The Dome

The bright orange sienna of the dome stands in brilliant contrast to the rest of the Duomo in terms of color opposites.

Having seen many pictures of this structure before, I was still dazzled by the size, symmetry, simplicity, and solidity of its design. My first impulse was to skip doing it because of its fame, much like skipping the Eiffel Tower or Big Ben. At the same time, something whispered, 'How can I make a Florentine journal without its famous landmark?'

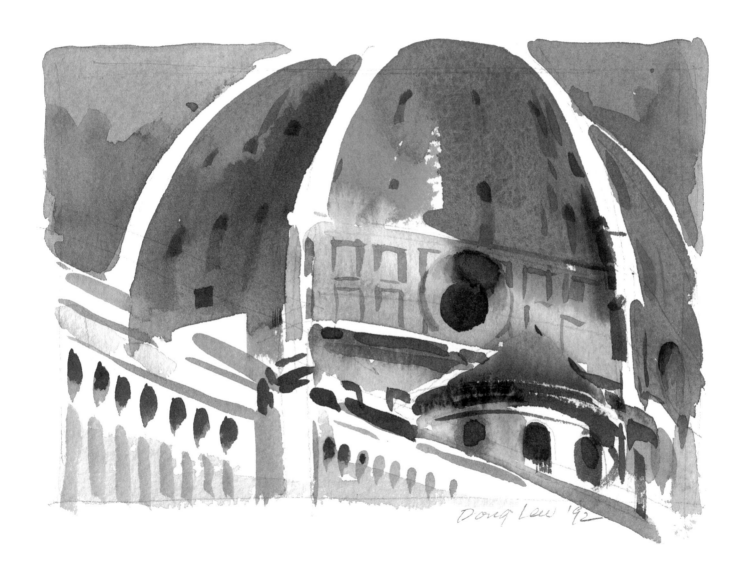

Doug Lew '92

6. Mosaic of Florence

Inside the Duomo I climbed to the level just above the circular windows, not even all the way to the cupola: already Florence stretched out magnificently below—a mosaic of Burnt Sienna, Cadmium Orange, Raw and Burnt Umbers. The height was enough to suggest that I could be seeing it from the very top, so I arbitrarily put in the dome tile below the sketch and curved it to round out a more pleasing composition. Even at that height, the urge to compose led me to make a better picture rather than a more accurate recording of the sight. I supposed an indication of the Palazzo Vecchio could better identify it as Florence.

At the moment, however, my fear of the height and the constant rustling of people made it difficult to carry out my task. I concentrated to capture the impression as best as I could. It's a sketch, I reminded myself.

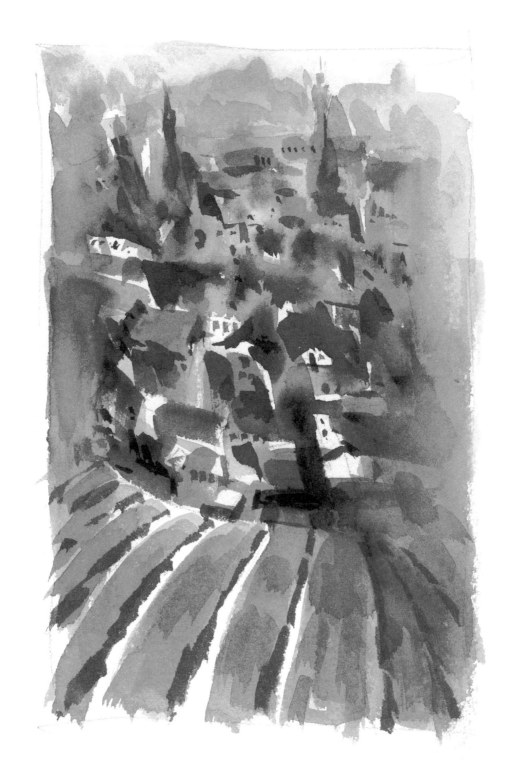

7. Near San Marco

I had been to San Marco to see the works of Fra Angelico, who lived and worked at the Monastery. On the way back I took side streets, and this view caught my eye. The torch holder or lamp post was there to light the darkness of night on such a narrow street. My imagination took me into the fascinating tales of intrigue and assassination of the Florentine Renaissance. It was mid-day and the street was quiet. I sat on the curb and sketched this scene.

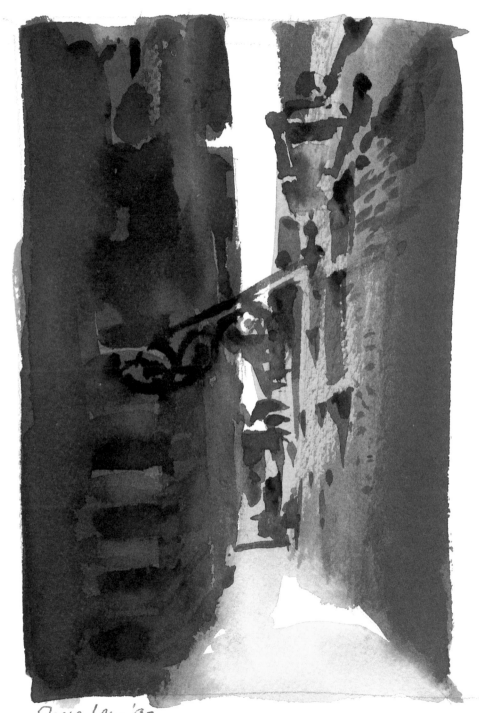

Doug Lew '92

8. The Iron Grill

Walking by Via Santo Spirito and then towards San Niccolò on my way home one day, I came upon this rather dilapidated Palazzo Capponi, whose window from the street is guarded by this immense iron grill surrounded by those huge stones again, reminding me that Florence during the Renaissance was a dangerous place to live in despite its glory. The sunlight coming from upper right cast a rich shadow on the stones and the window pediment. I put it down quickly with only one color, sepia. The grill was penciled over the dark window and finished later in the studio.

9. Florentine Stone

It is by far the most imposing material one finds everywhere in Florence. To me, it is simultaneously intimidating and fascinating. Intimidating in that it seems the whole city is built out of this massive stone, like little fortresses within a small city, making the exterior architecture not very pleasing. Fascinating in that some of the older stones seemed to have been deliberately chipped in order to give off a glimmer when sunshine strikes upon them. I cannot verify that such was the intention, but it does make the buildings more beautiful on a sunny day.

10. Florentine Lace

Having just sketched the stones I happened to come across a lace shop almost right next to the stone building. The delicacy immediately struck me as an interesting play of the opposites.

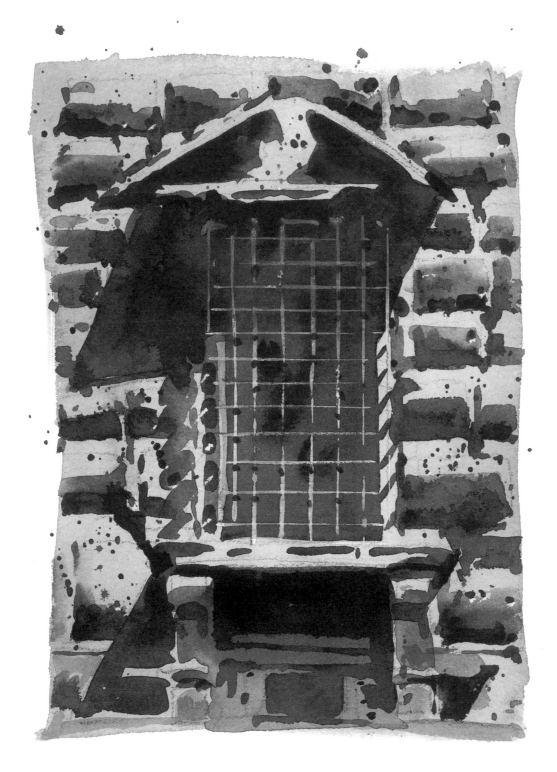

Doug Lew '92

Doug Lew '92

11. Dawn

San Lorenzo is most closely associated with the Medici family and it is a true shrine to the art of Brunelleschi and Michelangelo. The sculptures in the New Sacristy attracted most of my attention. I thought all of them magnificent—the Dukes, Day and Night, Dawn and Dusk. All of them are vividly life-like with Michelangelo's special touch of languidly twisted figures.

As the tourists dispersed, there was an excellent moment to do this famous woman in the New Sacristy. In my drawing sessions with a live model I often experiment with different colors to portray the skin tone of the figures, and it occurred to me that I could do the same without some curious or indignant onlookers wondering what I was doing to this revered sculpture. I've always thought Michelangelo never did justice to the female figures. They look just like male models with little cups of breasts stuck on them to make it appear female. They have none of the grace of the ancient Greek or Roman female sculptures. Nonetheless, I had a good time thinking about him as I experimented with my imaginary colors.

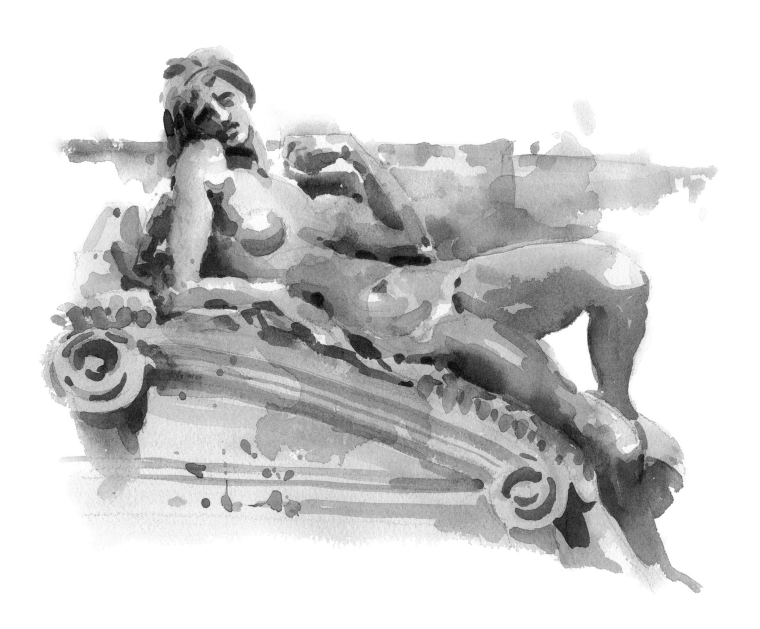

12. Santa Maria Novella

Having heard that its architecture is one of the finest in Florence, I went there with great anticipation. However, I found its style in some way indefinite, and did not feel particularly inspired. On the other hand, I was feeling a bit guilty for not having done anything. Outside the entrance there were the usual souvenir and postcard stalls. It's difficult to do a postcard stand without making it look as busy as it already was. I simplified it as much as I dared, hoping it would still read as a postcard stand and still include a part of Santa Maria Novella.

It turned out to be a compromise—a combination of the sublime and the absurd.

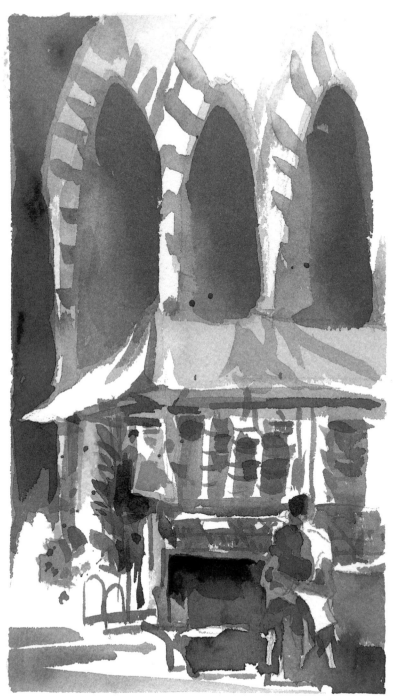

D.Lew'92

13. Piazza della Signoria

The layout of the square was very hard to depict. The sculptures were scattered around the square with no particular piece or groupings as a focal point. I picked this view so that at least pictorially I had a focal point. This famous piazza deserves another close scrutiny on my part to somehow sum up the grandeur of this most popular place.

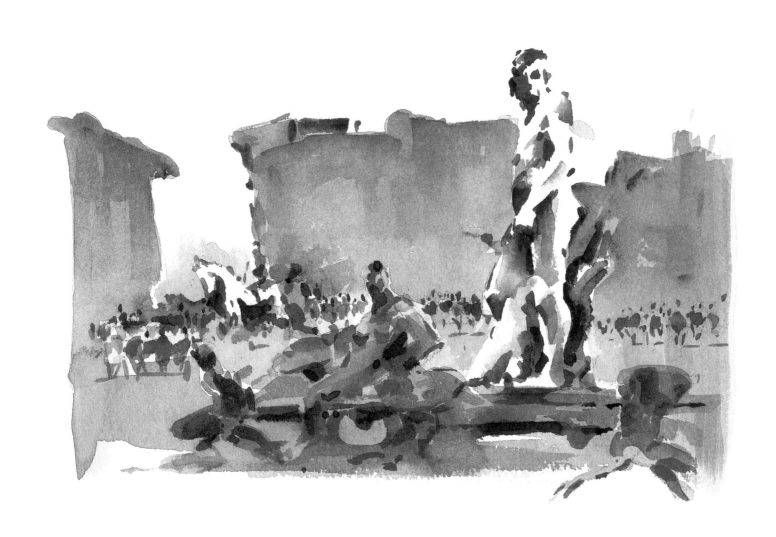

14. THE MEDICI COAT OF ARMS I

I am not an astute student of history but I am curious about many things historical. The Medici family is one of them. Now, I wish someone would tell me whether the balls on the Medici crest are medicine pills or some mace bashes? I've heard both.

Whatever it is, you certainly can find a lot of them. I didn't realize the power and influence of the Medici was so widespread until I saw the crest in Pisa, Siena, Arezzo and Montepulciano. It must be in many other places. One can find it in sculpture form, on tapestries, above a gate, on marbled floor, in frescoes…

This one was the most elaborate and most beautiful I saw in Florence. I concentrated on recording it as accurately as time allowed.

15. THE MEDICI COAT OF ARMS II

The second one is inlaid on the marbled floor of the Princes' Chapel in San Lorenzo. The worn and faded look added to its charm. It reminded me of an imprimatur, stamped and visible everywhere to remind you of its power and territory.

16. THE MEDICI COAT OF ARMS III

The third one is on the Palazzo dei Cavalieri in Pisa. Sunlight was coming from the left offering good light and shadow. As I sketched, I was puzzled by the Maltese Cross on top of the crest. Since the Medici are known bankers and financiers, could they have made some kind of alliance with the famous Knights of Malta—an Order that's the envy of all the rich and famous?

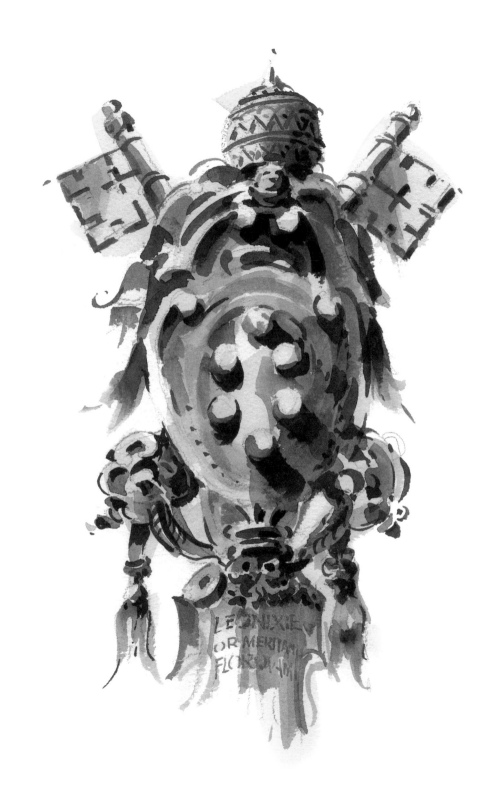

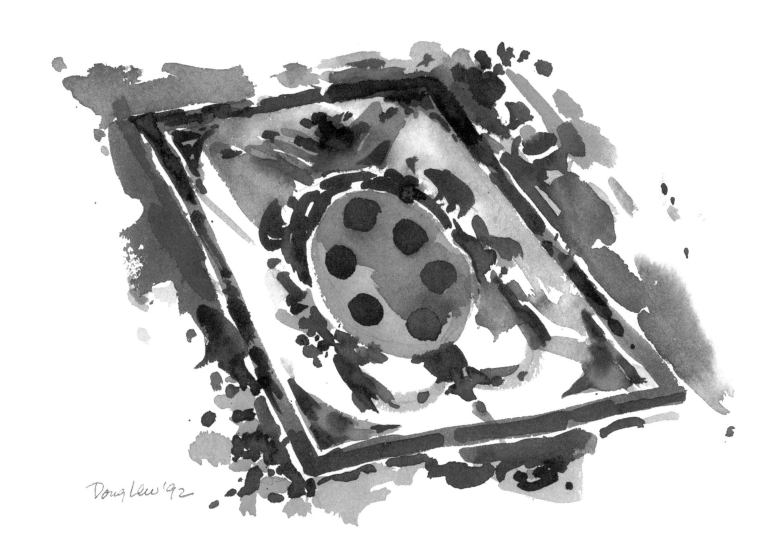

Doug Lew '92

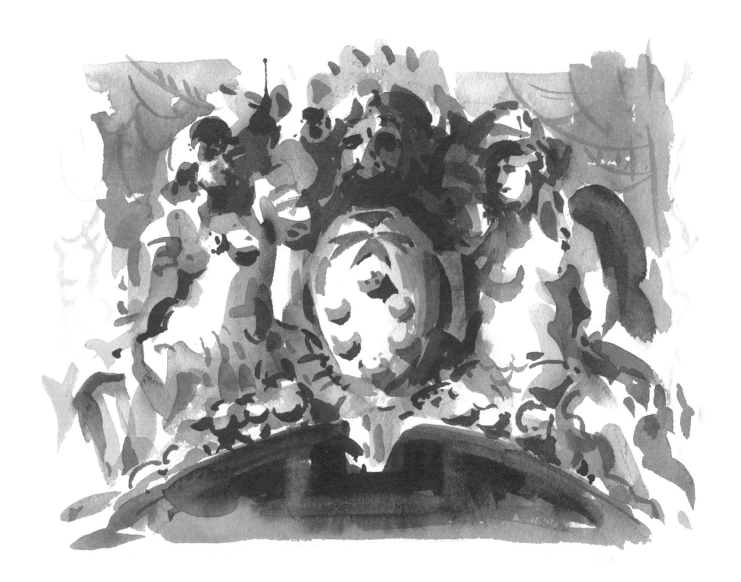

17. PALAZZO DAVANZATI I

This tall and narrow palazzo was my favorite. The surprising furnishings gave it a distinct flavor of the intimate aristocratic life in Renaissance times. To me, seeing live objects stirred the imagination as nothing else could. I was most struck by the architecture of the courtyard.

The building still has the stern appearance of a fortified structure; but in spite of its austerity, the gracefulness was almost magical, formed by arched pillars intertwined in layers of unexpected turns. I wanted immediately to capture that effect.

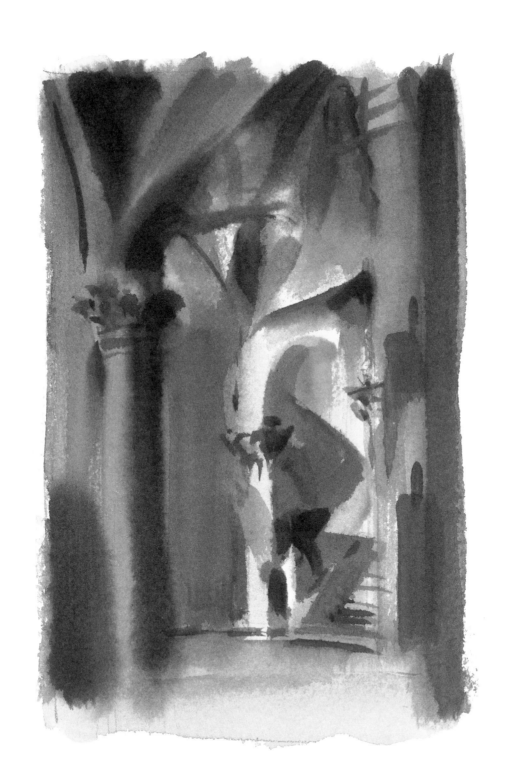

18. Palazzo Davanzati II

This view was also from the courtyard—a closer and more straight-on look at the staircase. The light was diffused and the shadow patterns cast on the architecture became even more subtle. The arrangement of values cast by the archways was so pleasing that I just had to give Davanzati another try. This one, to me, came closest to a thought-out painting.

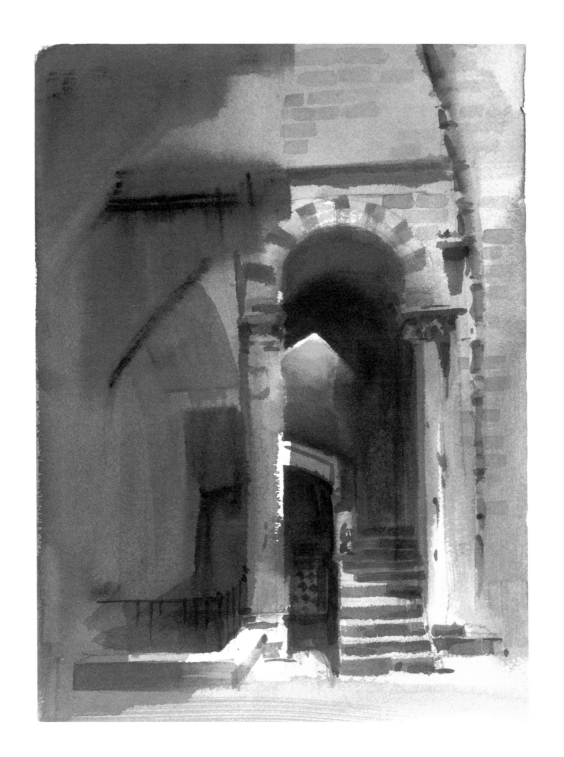

19. VIEW FROM PIAZZALE MICHELANGELO

Having had a huge Italian ice-cream cone Linda and I bicycled to the piazza. This late evening view wiped out all the glaring details one sees in bright daylight, giving it a totally different look—a soft monochromatic study of values and shading.

It was a good exercise of the wet-into-wet technique of watercolor.

20. PONTE VECCHIO AT DAWN

Everyone goes to Ponte Vecchio, but sketching on the bridge could be a daunting task. The young tourists seemed to live on the bridge by the statue either eating, sleeping or just eyeing each other. The street-cleaning crew were very busy with water-spraying trucks going back and forth to keep the bridge clean.

I wondered what it would look like at the crack of dawn. Will some tourists still be sleeping there? Well, before I even got close, I caught this view. Terrific! The early dawn light made everything simpler and moodier. I separated the buildings and hills behind the bridge by softening the edges and I made it monochromatic. The details of the bridge were by then quite clear but I deliberately simplified it and gave it some indication of structure by just a few strokes of darker shades while the first wash was still wet.

21. PONTE VECCHIO CLOSE-UP

Looking at the bridge in bright sunlight was totally different. My first attempt at sketching it failed when I tried to take in the entire bridge—too ordinary. One small part of the bridge looked like a small building painted in pink. For the second try, I decided to zero in on that strange color. I almost abandoned it until I saw a faint look of an abstract pattern that I liked. So I just left it, hoping the definition of the bridge could be carried by a simple half-arch.

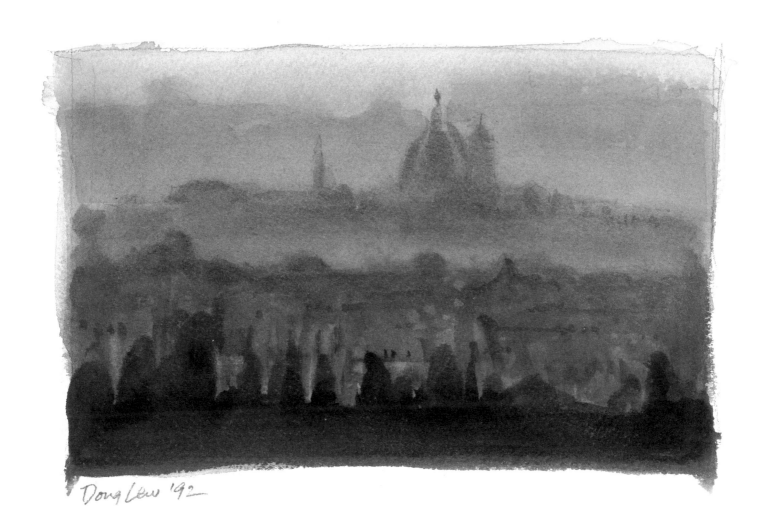

Doug Lew '92

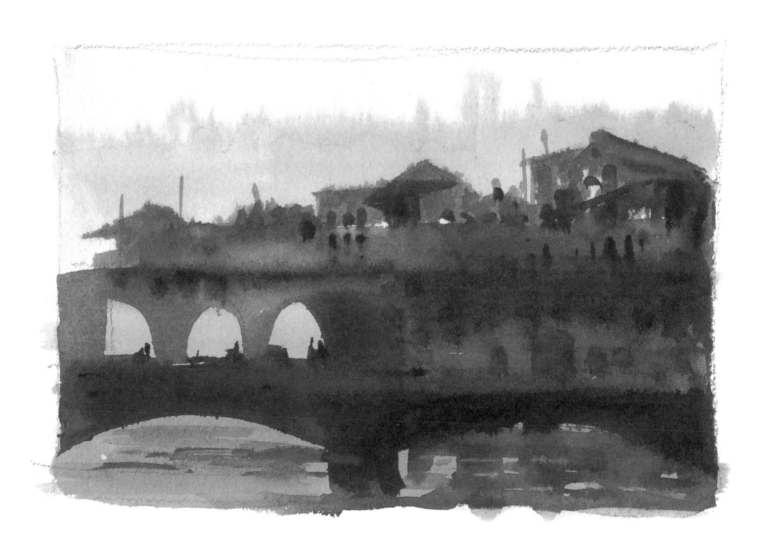

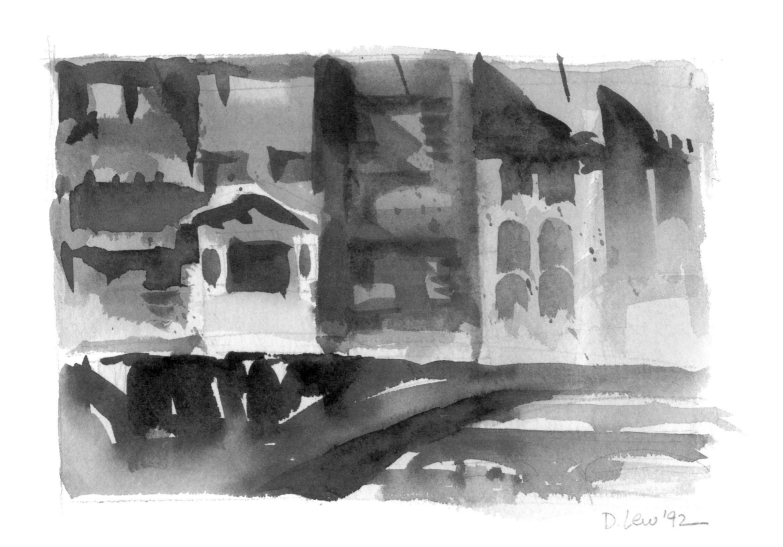

D. Lew '92

22. Arno at Dusk

A quick look at the river on a cloudy late evening gave me just enough time to get the light down. The light reflection on the river was actually brighter than the sky, which was very cloudy with hints of clearing at the very top. I gave the bottom a special shot of darkness to add drama to the view. The distant city in the middle of the sketch was added later in the studio when I had more time to think about the correct shading to use in order to suggest dusk. Then I used an exacto knife to scratch here and there to indicate the flickering lights of the beginning of night.

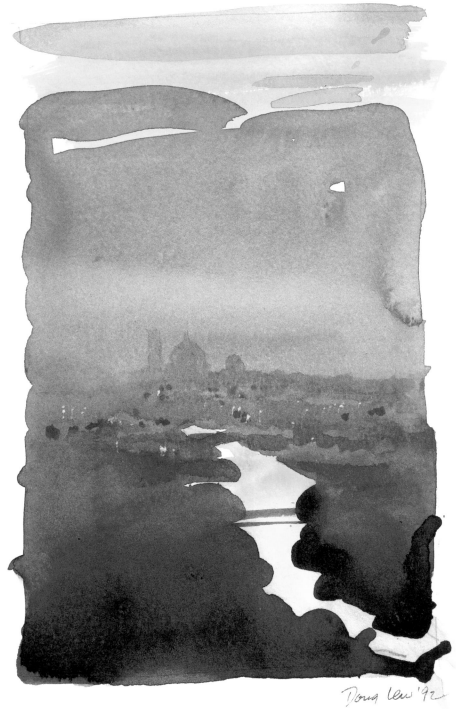

23. ARNO IN DAYLIGHT

The bright sunlight gave the Arno a completely different look. I took the liberty of changing some of the buildings to white and deepen the blue of the water in order to emphasize the brightness and also to give the composition an extra kick of contrast.

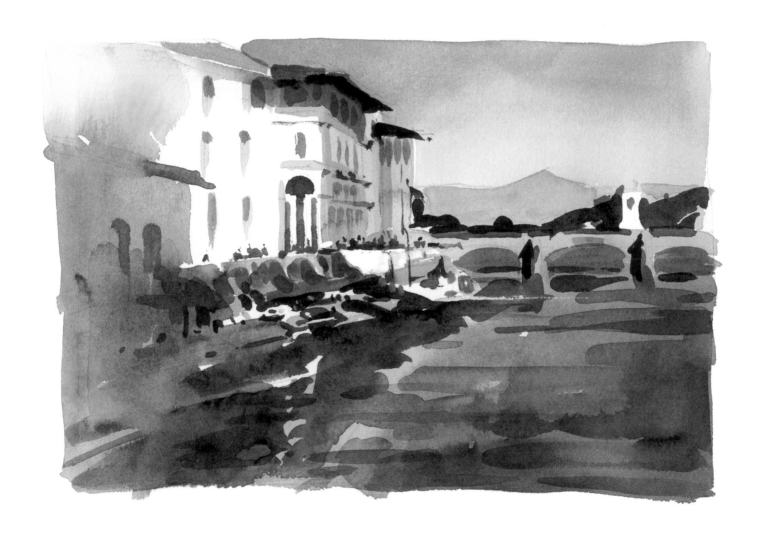

24. Piazza di San Pier Maggiore

It was high noon and I couldn't find a comfortable place to take in the whole piazza. I finally backed away as far as I could and settled on a perch on top of a garbage can and just holding the sketch book on my lap. Linda was feeling sleepy and went to the restaurant on the left to have a strong cup of espresso.

This sketch took longer than I anticipated as the group of figures to the right kept changing. Scooters and bikers came in and out of the scene every time I tried to commit to putting down some people. The two archways housed our favorite bakery and wine store, so I was determined to get this scene down before I lost it. We would want this one at home.

25. The Antiques Market

Not far from where we stayed on Via Farini was this antiques market, Mercato delle Pulci. On some days it looked quite bare and abandoned. The worn and faded carvings on the building made it look even more forlorn. I was told that in the old days this loggia was a fish market, so I portrayed it as it might have appeared—with the awnings and food stalls of a colorful and busy marketplace.

26. The Market of Sant'Ambrogio

Just a stone's throw away from the loggia was this bustling market with stalls both inside and outside of buildings. I found the subject a little difficult to do with so many bright items and people to focus on, so I settled on making the canopies the dominant element of the composition and kept the colorful produce and people as bustling as I could. A woman was buying some mozzarella cheese and I heard her jokingly asking the vendor how many hours ago was it made. My, the Italians do eat well! And fresh!

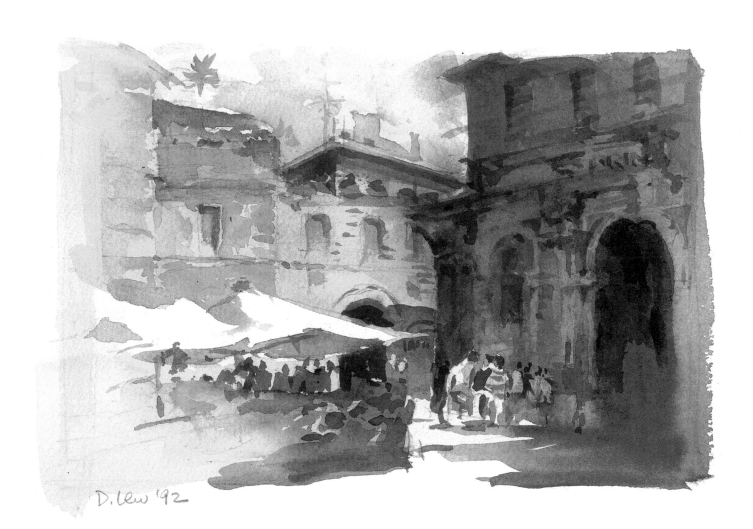

D. Lew '92

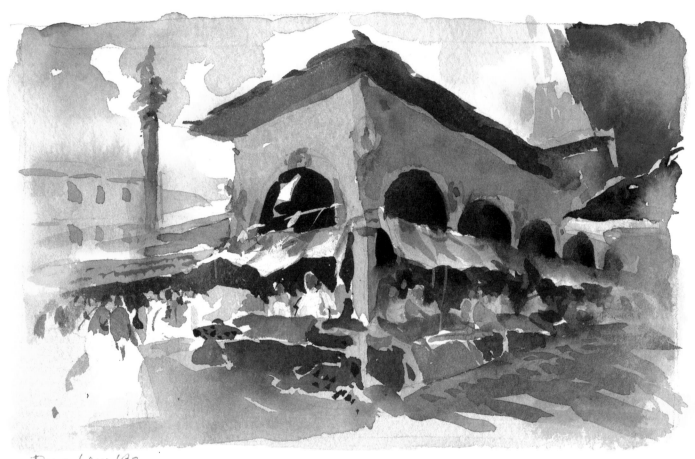

Dong Lew '92

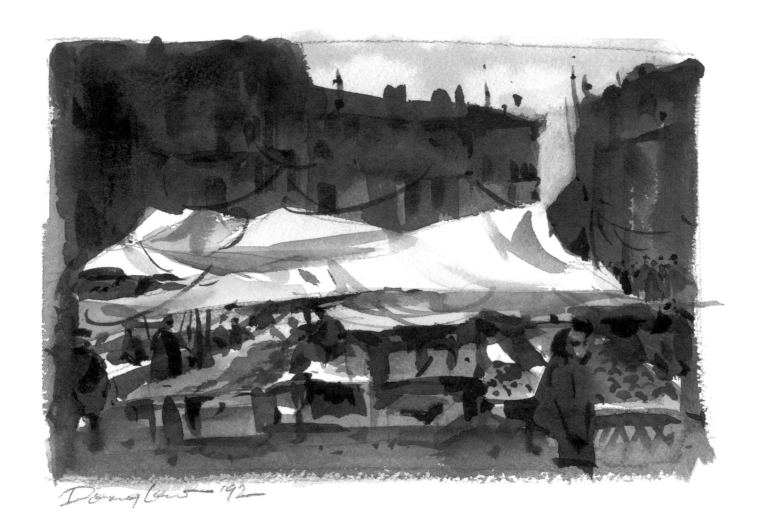

27. Santa Croce

I was looking for a hardware store to replace a broken shopping cart. The directions I received for the store brought me on a narrow side street. Suddenly I came upon a huge square and this famous church.

The interior turned out to be my favorite of all the churches in Florence. It was bright, airy and cool, with many works of art in clear view. The famous people, such as Michelangelo and Galileo, who were buried here reminded me of Westminster Abbey in London. The marbled floor was magnificent but badly showing its wear in many places. I decided on a sharply angled exterior view. The spot I picked was comfortable and out of the way of the bustling crowd.

I shall always remember how serendipitously I came upon Santa Croce!

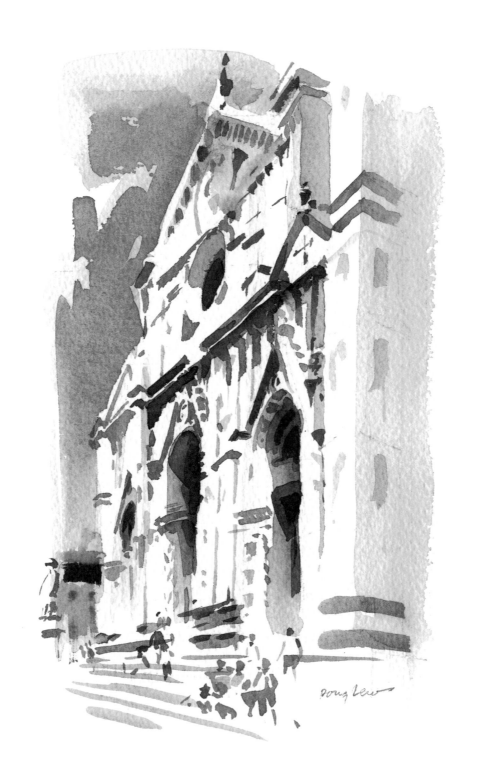

28. Linda and the Laundry

It was mid October. We were touring the countryside and carrying some laundry still wet from a previous night's stay at a small hotel that had no dryer. In the back of the Restaurant Belvedere there was a tiny backyard with some clotheslines half-empty. We asked the owner if we could put up a few things to dry. He readily agreed.

The trees had turned a flaming red. I couldn't resist.

29. The Laundry I

I did two other sketches of this subject. The sight, unusual to me, presented an interesting arrangement of shapes—almost abstract. I have since learned that Florentines prefer to dry in the open air for economy and fresher-smelling laundry.

The only change I made was to make the sheets all white to contrast against the darker tones of the buildings.

30. The Laundry II

Oh, let there be nothing on earth but laundry,
Nothing but rosy hands in the rising steam,
And clear dances done in the sight of heaven...
Richard Wilbur, "Love Calls Us to the Things of This World"

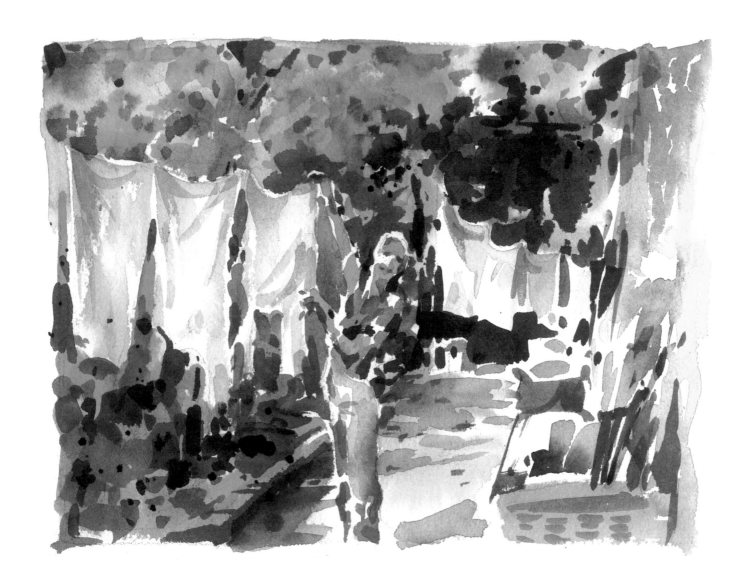

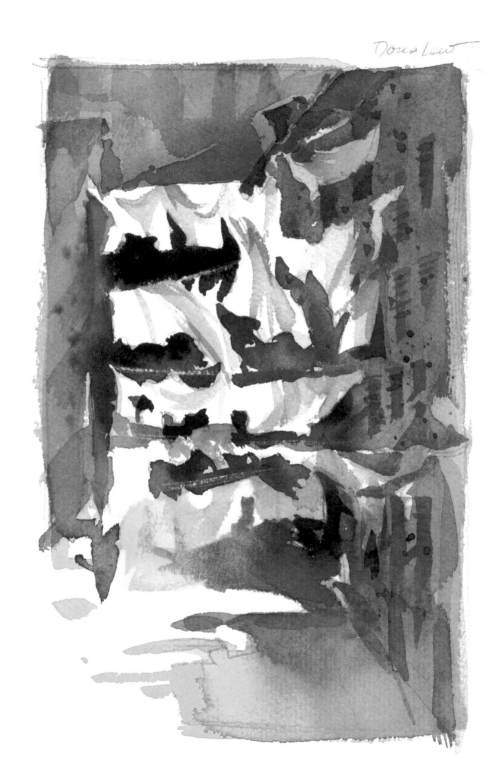

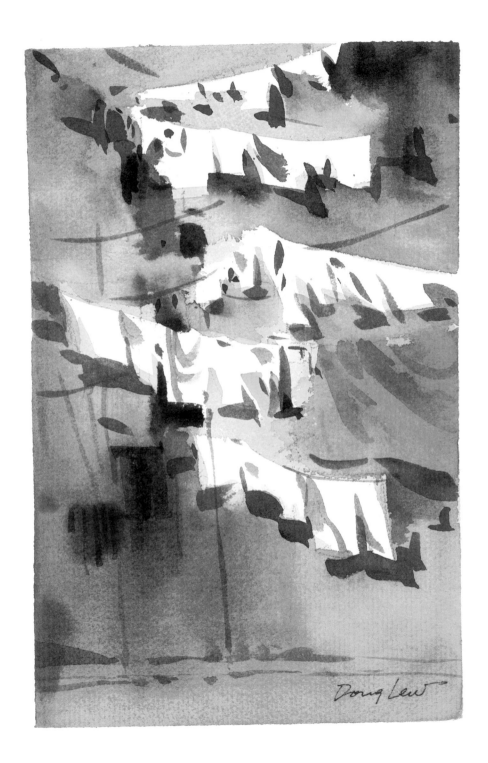

31. The Tribunal

This is the left side of a complex of buildings which houses the courthouse for judicial hearings. It's one of a few buildings that I could look at from a distance—in this case, from across a square. It's light, airy and for a tribunal it looks quite different. Uniformed policemen were going in and out of the right side of the entrance.

Courthouses in America look stoic, and official. I couldn't resist making the sketch, especially knowing the function of the building. There are worse places to hear one being sentenced!

32. Bargello I

It was interesting to learn that this national museum was once used as police station. It houses a truly fine collection of art. The indirect lighting from the outside was bright, filling the interior with clear but diffused light with subtle changes of tone. I decided to give it a try by concentrating on the effect of light and keeping the art objects as simple as I could.

33. Bargello II

Lighting in architecture always intrigues me. This view combines the openly lit courtyard below and the concentrated daylight coming from the window of a dark hallway. I thought it would be interesting to capture that effect. Again, I did so at the expense of generalizing the details.

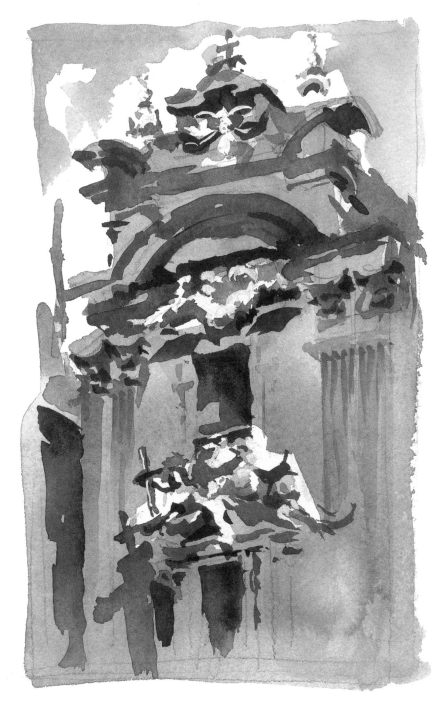

D.Lew '92

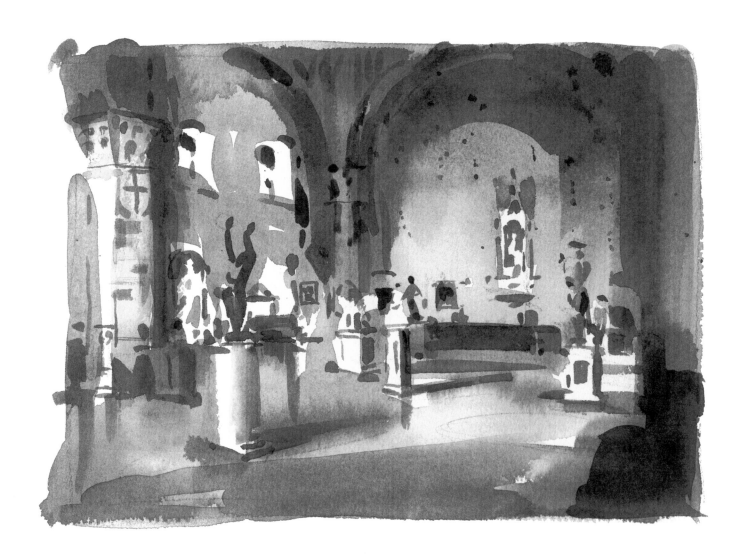

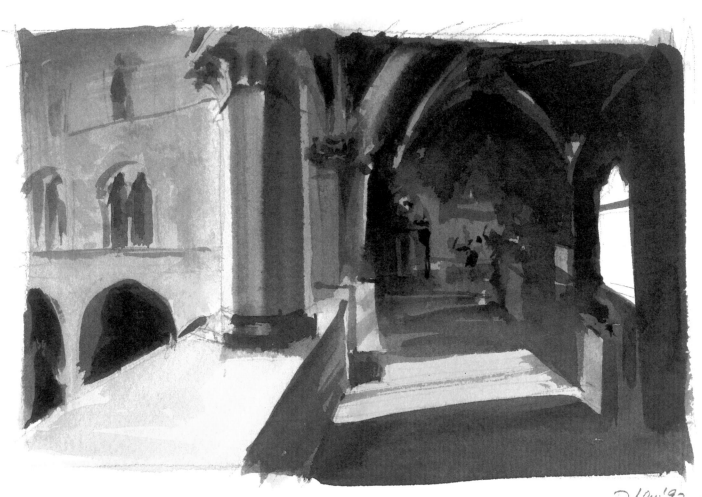

34. Garden of the Giant

One day we were taken by friends to a picnic on the outskirts of town. On the way back our friends urged us to stop by this garden because they thought it would be an interesting subject for me to paint. They were right. The statue was built in such a rough way that if you are not careful you might mistake it for a small mount. But on closer examination you can quickly make out the shape of a giant. So I decided to do the same.

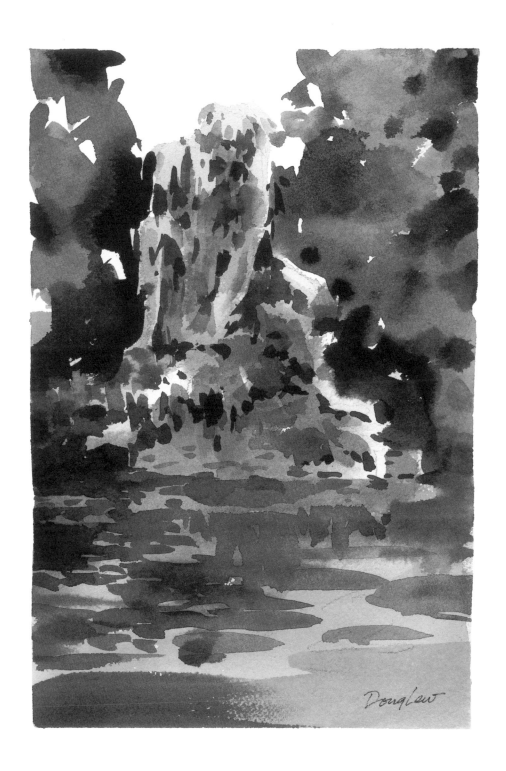

35. Convent of San Francesco

On top of Fiesole there is a complex of church and convent. I got permission to look around part of the convent, and this tiny cloister caught my attention. There was hardly anyone there, so I settled into this cozy corner and did this study. It went incredibly fast: the little green area was perfectly enclosed by the walkway, and the sketch almost composed itself.

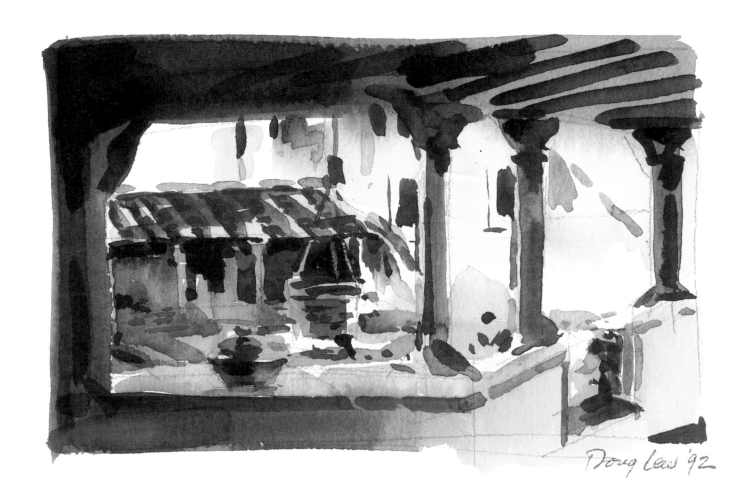

Doug Lew '92

36. The Synagogue

The Synagogue was directly across the street from where we stayed. I had tried to do this once before but it rained when I was just in the middle of it. From the top of the building where we stayed, I could get a more complete view of the building. Inside the synagogue every inch of the surface was painted with intricate designs and patterns, but what surprised me most was that in front of the building there stood palm trees. I wouldn't call Florence tropical, but there they were.

37. The Garden

Here is the very first thing I sketched immediately after arriving at the apartment of our friends. We were surprised and delighted to find this lovely little garden which connects to the patio of the home in the middle of the city. While Linda unpacked our baggage I sat down and painted. I will always remember the tranquillity of the setting, the distant sound of someone practicing the piano and the sounds of dishes of a noontime meal. Strange how sounds do things to jog one's memory.

38. Piazza D'Azeglio

Just one block from the house where we stayed, this charming park offered just the relaxation one needs in this near-central part of the city. It took up a whole block and was heavily shaded. It was just far enough from the heavy traffic around it to offer a welcome rest.

 As I painted a mother was taking a walk with his grown son who was blind. They kept circling around. Suddenly she asked why I put the figure in red on the right side where there was obviously no one there. I told her it needed a touch of warm to relieve the overall green look. She nodded in half agreement.

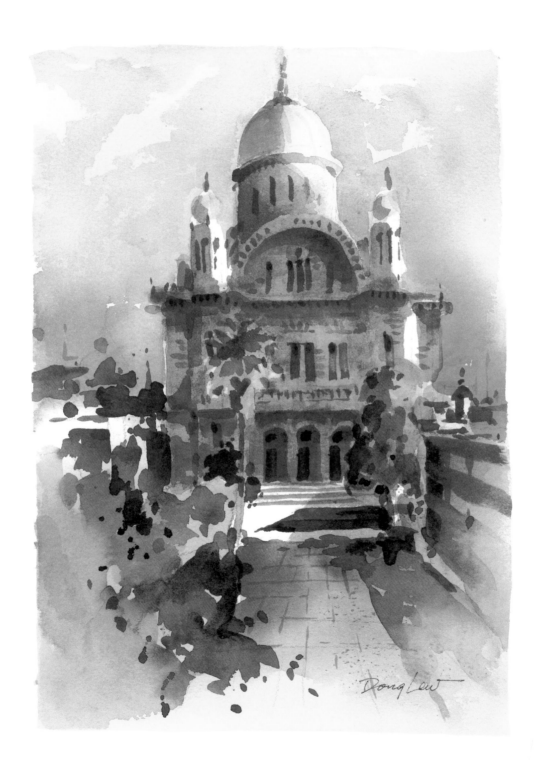

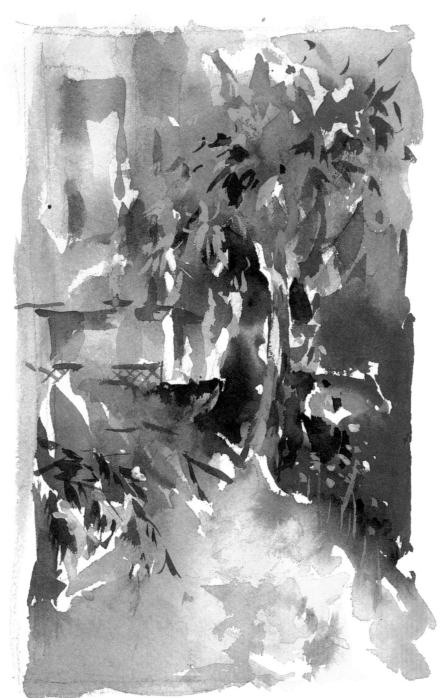

Doug Lew '92

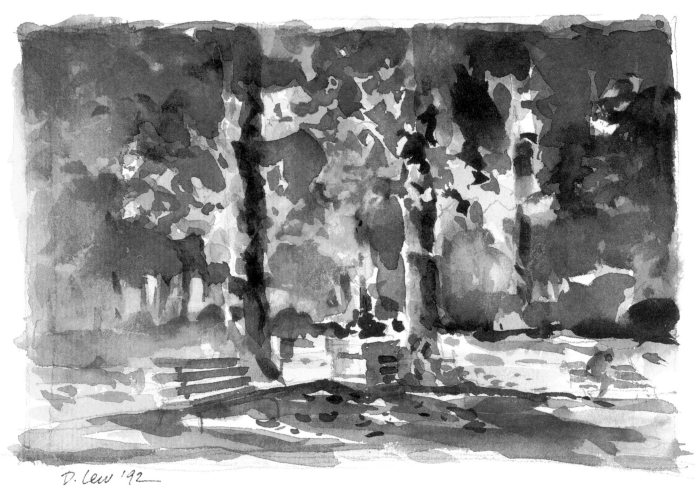

D. Lew '92

39. Miniature Garden

Above and around San Pier Maggiore the living quarters are cramped but you can spot little palm trees, flowers and greenery sprouting from the windows or from little balconies. The love of nature is universal. This little old woman watering her bit of green in a congested urban area is a true testament to that yearning. This sketch was done right after finishing the one on the previous page, and it was done in no time.

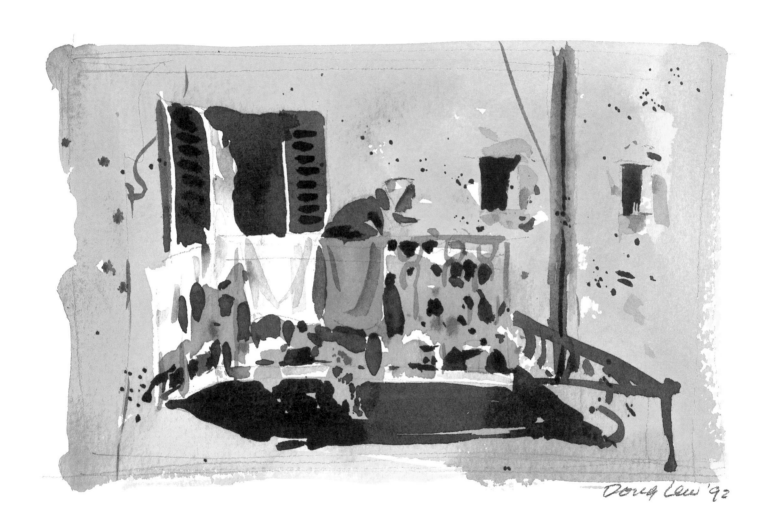

Doug Lew '92

40. Back Street

As I walked the side streets away from the city center they could be very quiet, especially after lunch. From what I saw, most Florentines have abandoned the practice of a good rest after lunch, but on many side streets I got the distinct impression that the little nap was still being taken. This day, a father and grandmother were dozing off while the children played, making no sound. The only noise I heard was an occasional sound of a scooter whizzing by!

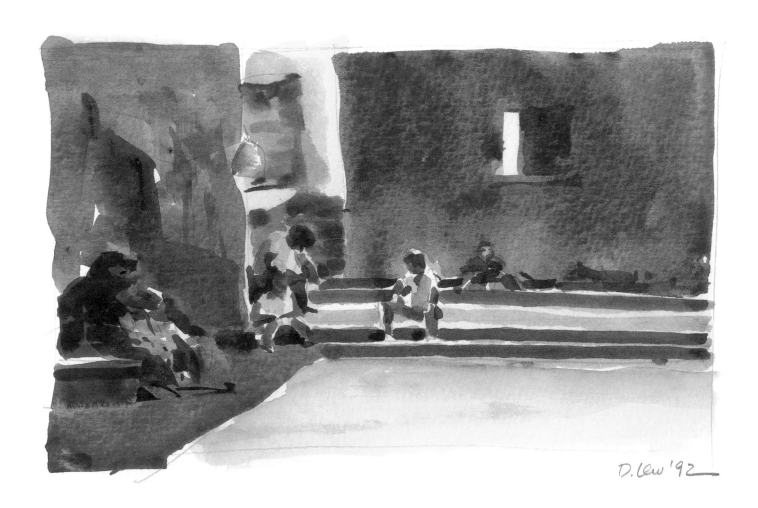

D. Lew '92

41. A Humble Doorway

After looking at the great doorways in Florence I thought it would be a nice counterpoint to do a most humble doorway. Greenery was all over the place, and it'd be a delight just to do this scene as a painter would do for his own pleasure. I hope the pleasure comes through.

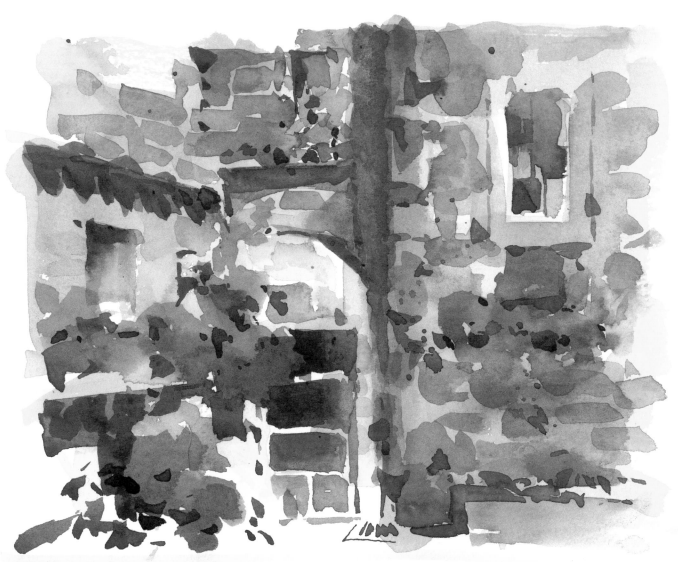

Doug Lew '92

42–44. Tuscany I, II, III

Since 1992 we have been to Florence several more times to sketch again in anticipation of this book and to visit the hill-towns in Tuscany. It was a delight to avoid the freeway and drive the back roads of Tuscany. The most distinctive look of Tuscany are the cypress trees. They were everywhere, clustering around a farm house or standing in a group in splendid and lonely isolation.

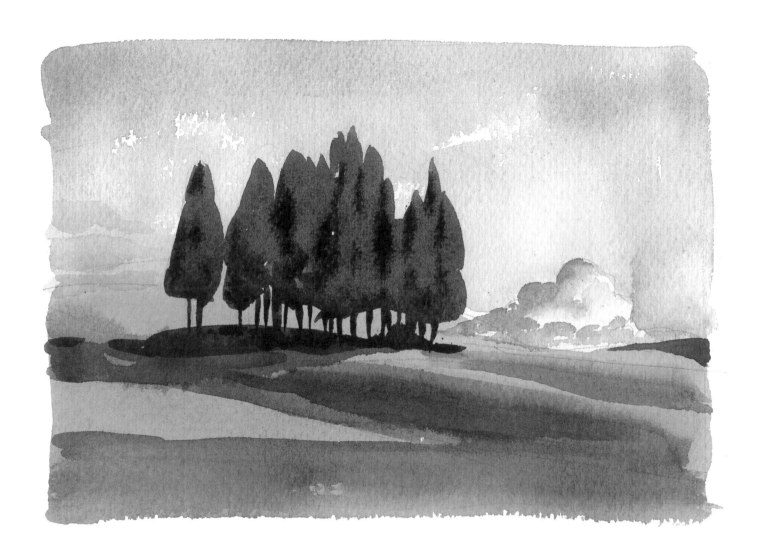

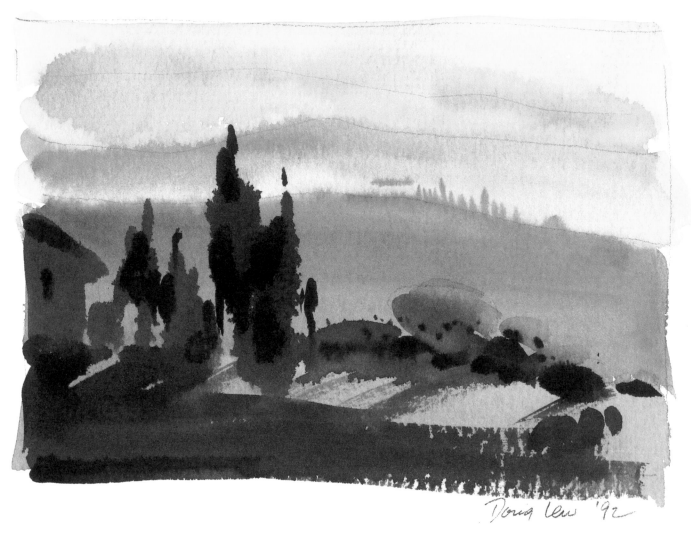

Doug Lew '92

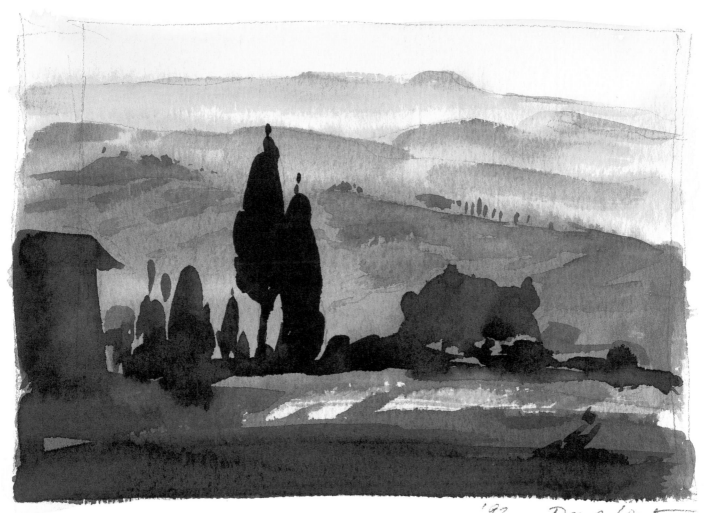

'92 Doug Lew

45. SAN GIMIGNANO AND VINEYARDS

San Gimignano is perched on a hill and from a distance it looks like an American city of sky-scrapers. Closer, one can see it's surrounded by a sea of vineyards. Some of the best wines come from this part of Italy. We bought an assortment of delicious things from a local *alimentari* and stuffed ourselves with some excellent local wine.

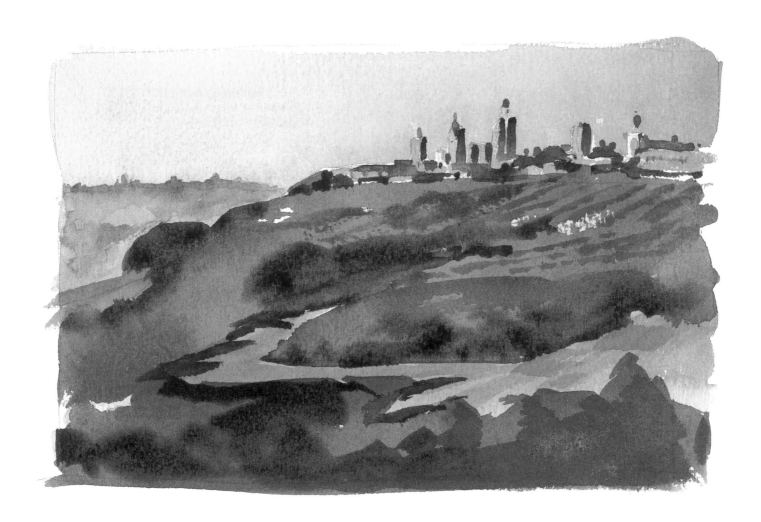

46. San Gimignano

Leaving the town in another direction I looked back and saw this view. The vast unplowed field in the foreground offered a dramatic composition. The sharp division of the field and vineyard made it easy for me to paint. I scratched the field with my credit card after a second, richer layer of Raw Sienna had been applied over the first layer of a lighter wash of the same color.

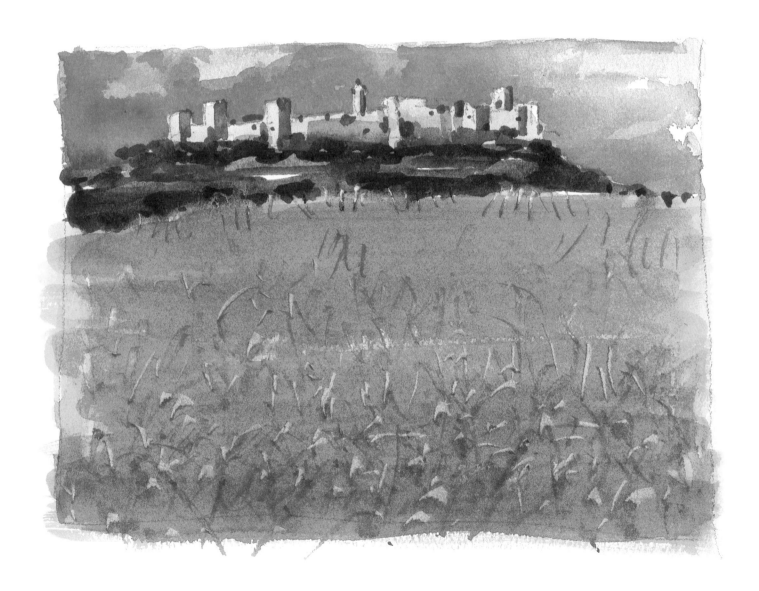

47. Siena. Piazza del Campo at Night

It's not difficult to do a night scene as long as where I work there is sufficient light to see what I'm doing. The only trouble is color fidelity; when ambient light shifts, so do the colors within it… So it's less important to get the colors right, and more so with values in order to convey the feeling of the scene. The attraction of the cafes on a warm evening has its own allure.

48. The Medieval Pageant

In Siena the annual Palio pageant was just about to begin. The flag-throwers were practicing in their gorgeous medieval attire. The clothes didn't look like costumes, unlike some of our Renaissance Fairs in America, where the costumes always look a bit false. The Italian clothes looked absolutely authentic—down to the horse coverings, the knights, and the armor. The whole spectacle was a work of art. I saw the same artistic care and detail given to the Venetian masks and costumes for the Venice Carnival. Nobody does it better than the Italians!

49. Flags

There was no time to put down the whole exciting event. Everything was moving so fast. But fortunately there were a few things remaining still—the flags. The colors were absolutely beautiful. Do you agree?

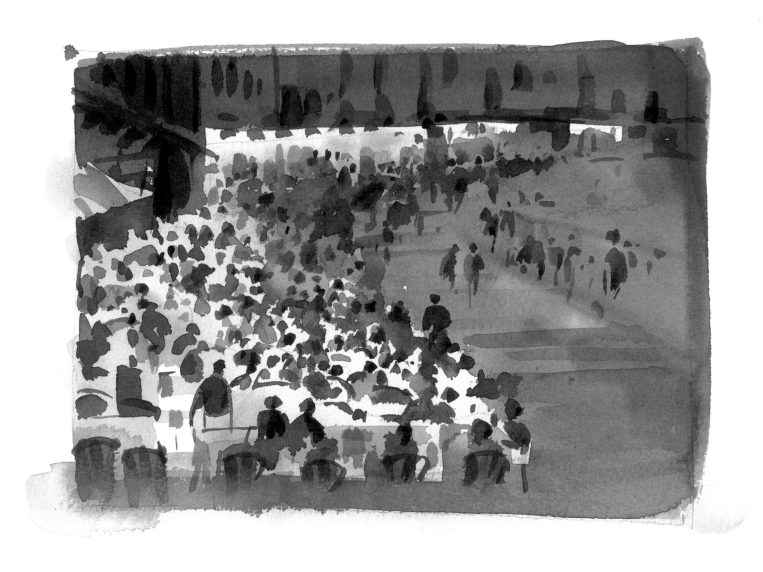

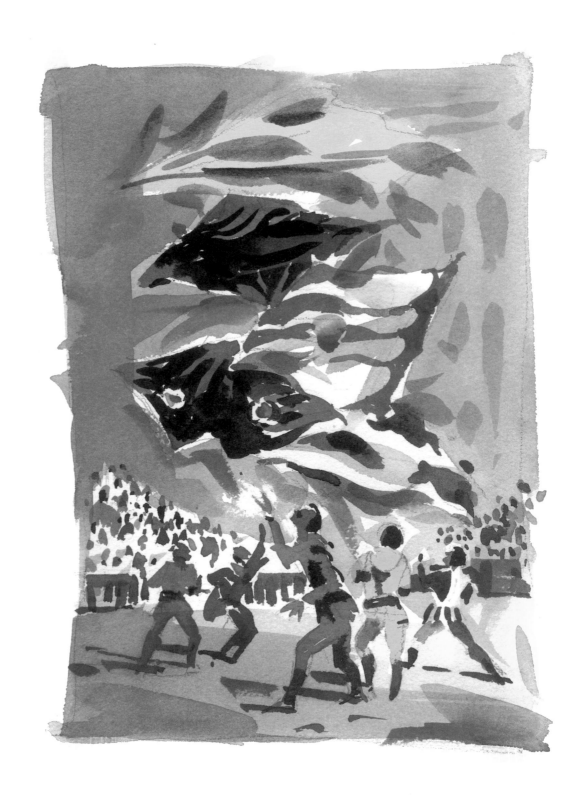

50. In Love with Florence

I have wanted to find a way to express my feeling towards this wonderful city, which gave me such pleasure in the people I met, the delicious food and wine I tasted, the glorious treasure of art and architecture I saw… and the joy of doing these sketches. Here is my note to Florence.

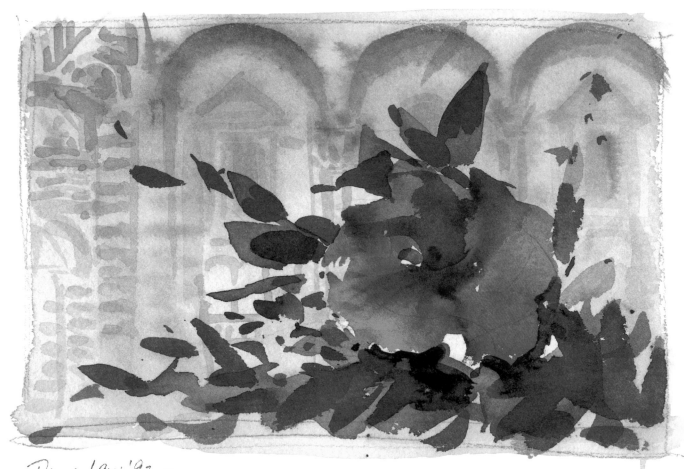

Doug Lew '92

TABLE OF CONTENTS

Printed by Alpilito – Firenze
January 2002